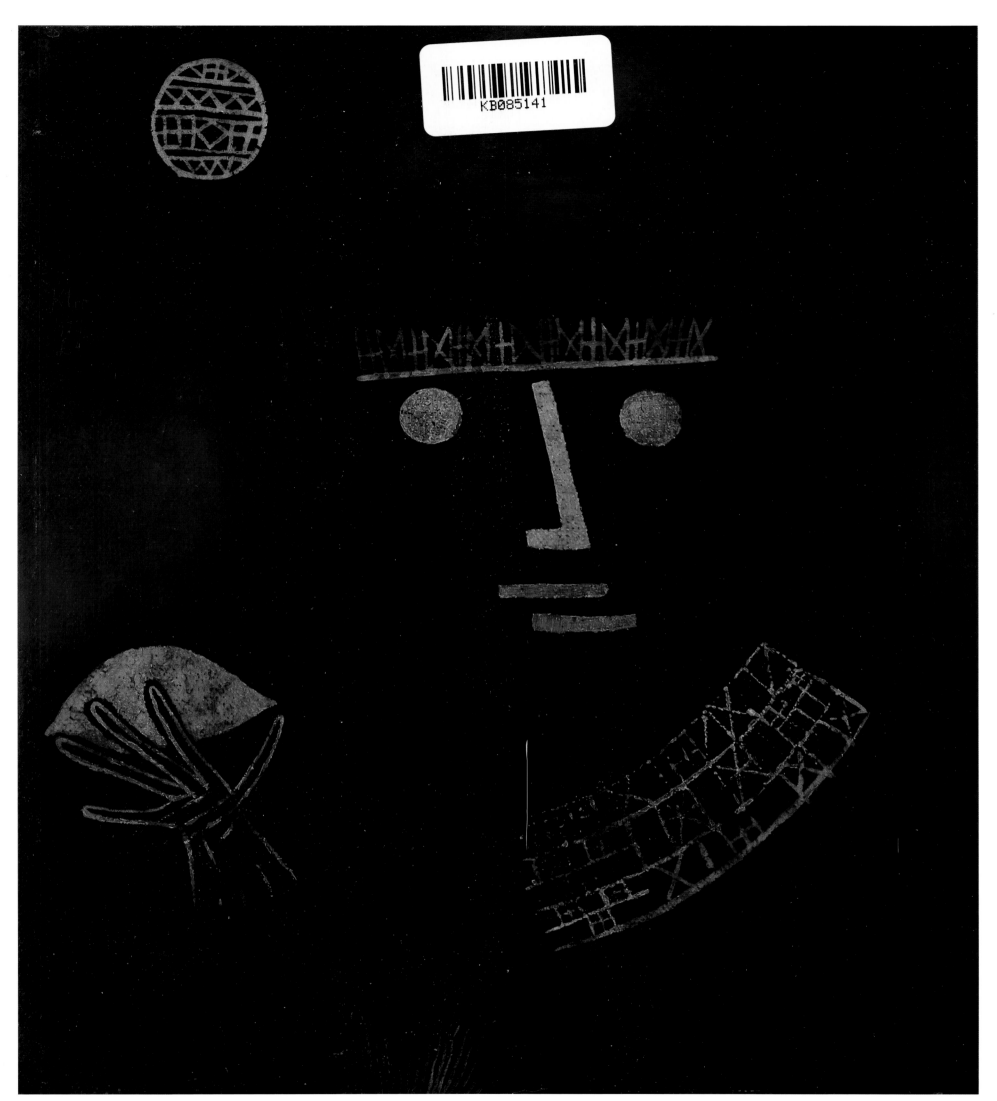

파울 클레 **검은 왕자**, 1927년

Paul Klee
Black Prince, 1927, 24 (L4)
schwarzer Fürst
Le prince noir
검은 왕자
黒の王子様

Oil and tempera on canvas, original frame, 33 x 29 cm
Düsseldorf, Kunstsammlung Nordrhein-Westfalen, Inv. 16

"Abstract? Being abstract as a painter does not mean abstracting from natural, objective comparative possibilities, but, independent of these comparative possibilities, rests on the extraction of pictorially pure relationships."

„Abstract? als Maler abstract sein heißt nicht etwa gleich ein Abstrahieren von natürlichen gegenständlichen Vergleichsmöglichkeiten, sondern beruht, von diesen Vergleichsmöglichkeiten unabhängig, auf dem Herauslösen bildnerisch reiner Beziehungen"

« Abstrait ? Etre peintre abstrait ne signifie pas abstraire immédiatement à partir de comparaisons possibles à un modèle donné ; cette notion repose, indépendamment de ces comparaisons possibles, sur l'extraction de relations pures sur le plan pictural. »

"추상? 추상 화가가 된다는 것은 주어진 모델과의 직접적인 비교에서 출발해 대상을 추상화한다는 의미가 아니다. 이 개념은 그런 비교와는 별개이며, 회화적 차원에서 순수한 관계를 추출하는 일에 기초를 두고 있다."

「抽象とは何か。画家として抽象的であるとは、自然である対象を比較の方法で抽象化することではなく、こうした可能な比較の形式から離れて、絵画的に純粋な関係を抽出するところに基礎を置くことである」

PAUL KLEE

Paul Klee

파울 클레

마로니에북스 TASCHEN

PAUL KLEE (1879–1940)

As in Novalis's texts, we find a unification of oppositions in Paul Klee's work. Mysticism and logic, poetry and mathematics, day and night, metaphysical and physical realms, the visible and the invisible, the conscious and the unconscious, childlike naivety and aesthetic sophistication, death and life, the organic and the inorganic, East and West, order and anarchy, irony and commitment, are often simultaneously present. For Klee, the making of art was a simile for the creation of the world. Like Goethe, whom he considered the "only bearable German", and whose experience of nature seemed allied to his own, Klee attempted to capture nature in terms of primal images; and like the poet, the artist discovered "analogies to the universal design in the tiniest leaf". On an early trip to Italy, undertaken with the Swiss sculptor Hermann Haller, Klee was intrigued less by the legacy of visual artists – with the exception of Leonardo – than by the structural principles of Italian architecture, which he saw as a continuation of natural laws by human hands, and by the fantastic aquatic flora and fauna in the Naples aquarium. Between these two poles lay the garden, organic nature domesticated and shaped by man, which inspired many of Klee's finest pictures. And it was between these two poles, those of construction and imagination, that his rich œuvre developed.

Wie in den Texten Novalis findet im Werk Paul Klees die Vereinigung des Gegensätzlichen statt. Mystik und Logik, Poesie und Mathematik, Tag und Nacht, obere und untere Welt, Sichtbares und Unsichtbares, Bewusstes und Unbewusstes, kindhafte Naivität und artistisches Raffinement, Tod und Leben, Organisches und Anorganisches, Östliches und Westliches, Ordnung und Anarchie, Ironie und Ergriffenheit sind oft gleichzeitig präsent. Kunst ist für Klee Gleichnis der Schöpfung. Wie Goethe, den der Maler für den „einzig erträglichen Deutschen" hielt und dessen Naturerlebnis dem eigenen verwandt erschien, suchte er sie in Urbildern zu fassen; wie der Dichter entdeckte der Künstler noch im „äußersten Blättchen Analogien zur totalen Gesetzgebung", wie er im Tagebuch notierte. Auf einer frühen Italienreise, die er gemeinsam mit dem Schweizer Bildhauer Hermann Haller unternahm, faszinierten ihn – mehr als die Hinterlassenschaft der bildenden Künstler mit Ausnahme Leonardos – die konstruktive Gesetzlichkeit der Architektur als vom Menschen fortgesetzte, gebaute Natur und die phantastische Meeresflora und -fauna im Aquarium zu Neapel. Dazwischen liegt der Garten als domestizierte, gewachsene und gebaute Natur, der ihn zu seinen schönsten Bildern inspirierte. Damit sind die Pole abgesteckt, zwischen denen sein reiches Werk sich langsam und stetig entfaltet: Konstruktion und Imagination.

Dans l'œuvre de Paul Klee comme dans les textes de Novalis, on assiste à l'union des contraires. La mystique et la logique, la poésie et les mathématiques, le jour et la nuit, le monde supérieur et le monde inférieur, le visible et l'invisible, le conscient et l'inconscient, la naïveté enfantine et le raffinement artistique, la mort et la vie, l'organique et l'inorganique, l'Orient et l'Occident, l'ordre et l'anarchie, l'ironie et l'émotion y sont souvent présents de manière simultanée. Pour Klee, l'art est une image de la création. Comme Goethe, le « seul Allemand supportable » dont la perception de la nature lui semblait proche, il cherchait à saisir la création en termes d'archétypes. Comme le poète, le peintre savait encore trouver « des analogies avec la loi cosmique jusque dans la moindre feuille d'un arbre ». Lors d'un voyage en Italie entrepris dans ses jeunes années avec le sculpteur suisse Hermann Haller, il fut fasciné – plus que par l'héritage des plasticiens (à l'exception de Léonard) – par la loi architecturale considérée comme un prolongement de la nature, mais aussi par la flore et la faune marines dans l'aquarium de Naples. Entre ces deux fascinations, on trouve le jardin, nature à la fois organique, domestiquée et construite, qui lui inspirera nombre de ses plus belles œuvres.

노발리스의 글을 읽을 때처럼, 파울 클레의 작품에서는 상반된 것들의 결합을 볼 수 있다. 신비주의와 논리, 시와 수학, 낮과 밤, 형이상학적 세계와 물질적 세계, 가시적인 것과 비가시적인 것, 의식과 무의식, 어린아이 같은 순수함과 예술적 세련미, 죽음과 삶, 유기적인 것과 무기적인 것, 동양과 서양, 질서와 혼란, 모순과 감동이 흔히 동시에 나타난다. 클레에게 예술 창작이란 세계 창조에 대한 직유였다. 클레는 괴테를 "견딜 수 있는 유일한 독일인"으로 평가했고, 자연에 대한 괴테의 인식은 클레와 유사했다. 따라서 그는 괴테와 마찬가지로 원형의 차원에서 자연을 파악하려 했다. 마치 시인처럼, 클레는 "하찮은 나뭇잎에서도 우주 구조와의 유사성"을 찾아냈다. 젊은 시절 스위스 조각가 헤르만 할러와 함께 이탈리아를 여행하면서, 그는 조형예술가들(레오나르도를 제외한)의 유산보다는 이탈리아 건축물의 구조 원리에 매료되어 그 법칙이 곧 자연의 연장이라고 생각했다. 또한 그는 나폴리의 수족관에서 본 수중 식물과 동물에도 매혹되었다. 이 두 매혹 사이에 정원이 존재한다. 이 정원은 인간에 의해 길들여지고 형상화된 유기적 자연으로서, 그의 수많은 아름다운 작품에 영감을 불어넣었다.

ノヴァリスが述べているように、パウル・クレーの作品は相反するもの同士を一体化させている。神秘主義と論理、詩歌と数学、昼と夜、形而上学的な世界と物理的な世界、実体のある現実、目に見えるものと見えないもの、意識と無意識、子供らしい純真さと審美的な洗練、死と生、有機と無機、東と西、秩序と無政府状態、運命のいたずらと宿命が往々にして同時に併存する。クレーにとって、作品をつくることは世界の創造に匹敵した。彼が「ただ一人、容認できるドイツ人」と考え、彼と自然の捉え方が似ているゲーテのように、クレーは一次イメージで自然を捉えようとした。また、詩人のように、芸術家は「最小の葉に普遍的なデザインの類似性」を見出した。若い頃、スイスの彫刻家ハーマン・ハーラーと共に出かけたイタリア旅行で、クレーはレオナルドを例外として、ヴィジュアル・アーティストの遺産よりも、人間の手によって受け継がれてきた自然の法則としての、イタリア建築の構造原則やナポリの水族館のすばらしい水生植物相と動物相に興味をそそられた。この2本柱の間に、人間が飼い慣らし形作った有機的な自然である庭が横たわっている。そして、それが数多くのクレーの洗練された作品を啓発した。建築と想像力という2本の柱の間で、彼の豊かな人生がゆっくりとたゆまず展開された。

포트폴리오
파울 클레

발행일: 2006년 3월 1일
펴낸이: 이상만
펴낸곳: 마로니에북스
등록: 2003년 4월 14일 제2003-71호
주소: (110-809) 서울시 종로구 동숭동 1-81
전화: 02-741-9191(대)/편집부 02-744-9191/팩스 02-762-4577
홈페이지 www.maroniebooks.com

ISBN 89-91449-39-5 (SET 89-91449-69-7)

Paul Klee : Portfolio
© 2006 TASCHEN GmbH
Hohenzollernring 53, D–50672 Köln
www.taschen.com
© VG Bild-Kunst, Bonn 2003
Cover: Camel (in Rhythmic Landscape with Trees), 1920, 43

Printed in China

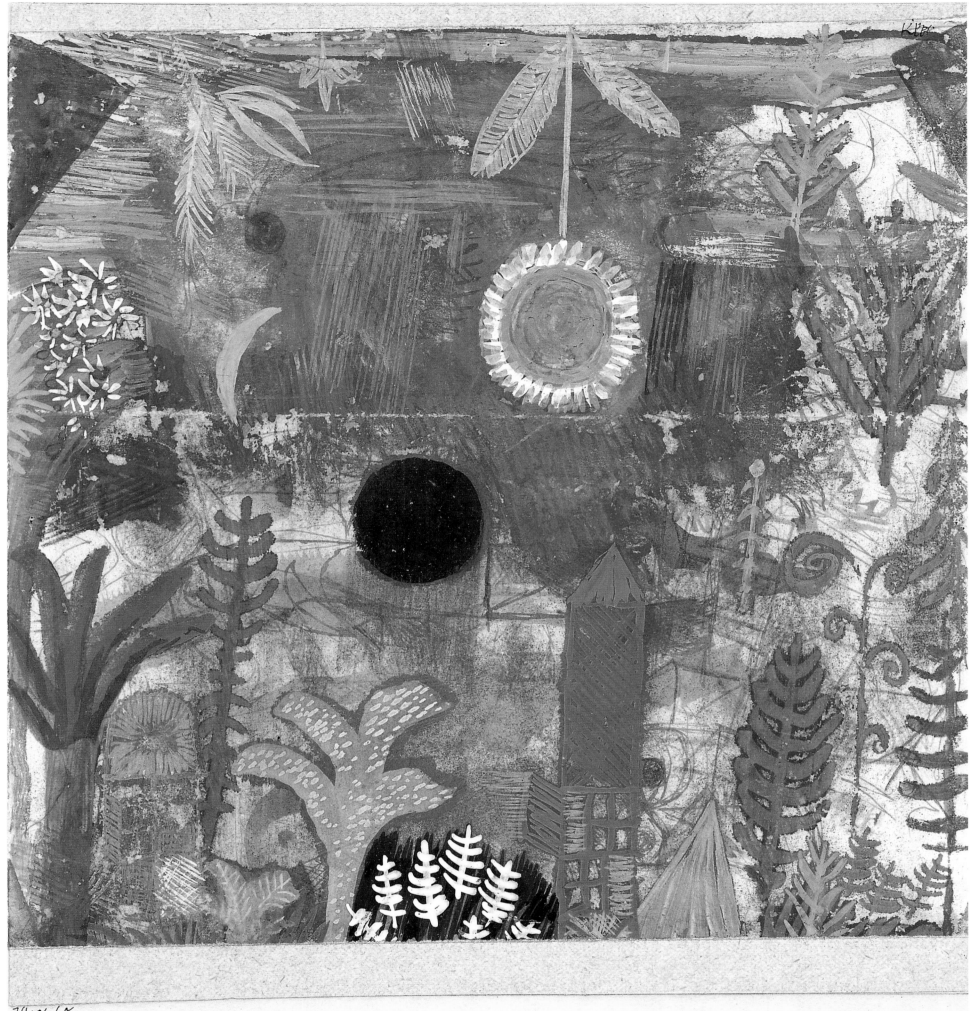

파울 클레 **가라앉은 풍경**, 1918년

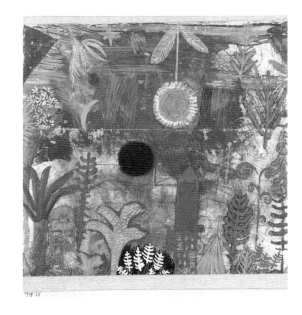

Paul Klee
Sunken Landscape, 1918, 65
Versunkene Landschaft
Paysage enfoui
가라앉은 풍경
沈む風景

Watercolour, gouache and ink on paper, glossy paper strips top and bottom, 17.6 x 16.3 cm
Essen, Museum Folkwang, Inv. C 3/58

"Nature can afford to be wasteful everywhere, but the artist has to be extremely thrifty.
Nature is almost dizzyingly talkative, the artist must be taciturn."

„Die Natur kann sich Verschwendungen in allem erlauben, der Künstler muss bis ins letzte sparsam
sein. Die Natur ist beredt bis zum Verworrenen, der Künstler sei ordentlich verschwiegen."

« La nature peut se permettre de gaspiller en tout, l'artiste doit être économe des plus petites choses.
La nature est éloquente jusqu'à la confusion, l'artiste doit être très réservé. »

"자연은 어디서든 낭비할 수 있다. 하지만 예술가는 아주 작은 것까지 아껴야 한다.
자연은 혼란스러울 정도로 많은 말을 하지만, 예술가는 말을 아껴야 한다."

「自然は至るところで無駄遣いができるが、芸術家は非常に倹約家でなければならない。
自然はほとんど絶え間なくおしゃべりを続けるが、芸術家は寡黙でなければならない」

PAUL KLEE

파울 클레, 「물고기」, 1925년

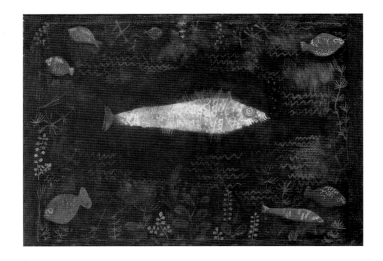

Paul Klee
The Goldfish, 1925, 86 (R6)
der Goldfisch
Le poisson d'or
금붕어
金色の魚

Oil and watercolour on paper and cardboard, 49.6 x 69.2 cm
Hamburg, Hamburger Kunsthalle, Gift of the Friends of Carl Georg Heise, Inv. 2982

In the middle of the picture in the dark blue water swims a patterned goldfish with short red fins,
a red tail and a red eye. It was pictures like this that were making Klee famous even then.

Im tiefblauen Wasser (Bildgrund) steht in der Mitte des Bildes der gemusterte goldene Fisch mit
kurzen roten Flossen, rotem Schwanz und rotem Auge. Bilder dieser Art waren es, die Klee schon
damals berühmt werden ließen.

Dans l'eau d'un bleu profond (le fond) se trouve, au centre du tableau, le poisson rouge tacheté,
avec ses courtes nageoires rouges, sa queue rouge et son œil rouge. Ce sont des tableaux comme
celui-là, qui, à l'époque déjà, valurent à Klee la célébrité.

그림 한가운데에 빨간 꼬리와 빨간 눈, 짧고 빨간 지느러미를 한
무늬 있는 금붕어가 짙은 푸른색 물속을 헤엄쳐 다닌다.
당시에 이미 클레를 유명하게 만들어준 그림은 이런 것이었다.

絵の中央の暗く青い水の中で、短いひれ、赤い尾、赤い目をした魚が泳いでいる。
こういう絵が当時クレーを有名にした。

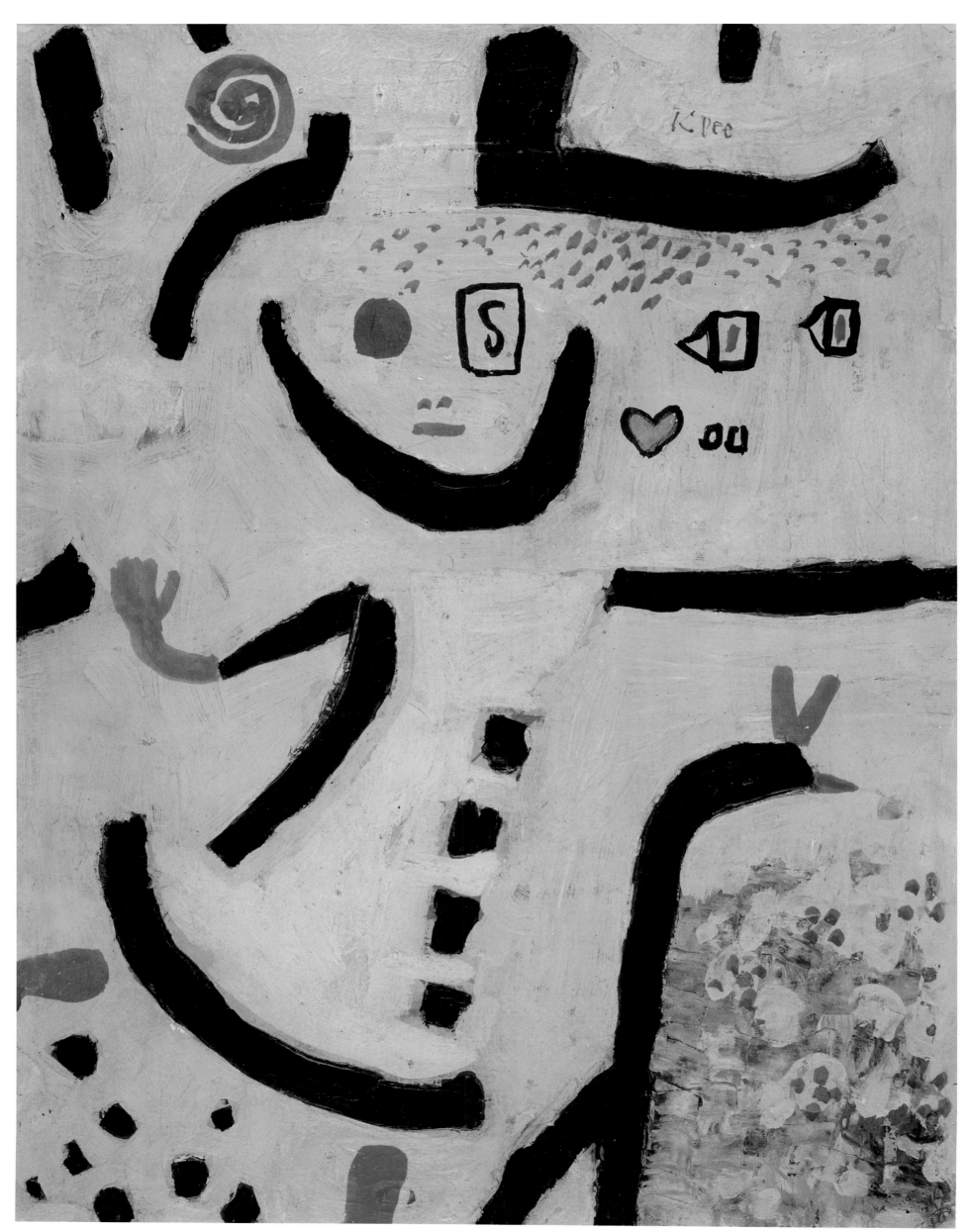

파울 클레 **아이들 놀이**, 1939년

Paul Klee
Children's Game, 1939, 385 (A5)
ein Kinderspiel
Un jeu d'enfants
아이들 놀이
子供の遊び

Poster colour and watercolour on cardboard, 43 x 32 cm
Berlin, Staatliche Museen zu Berlin, Sammlung Berggruen

"If my things sometimes give a primitive impression, then this can be explained by arising from my discipline which seeks to reduce to a few steps. It is only thrift, the final professional know-how, actually the opposite of true primitivism."

„Wenn bei meinen Sachen manchmal ein primitiver Eindruck entsteht, so erklärt sich diese Primitivität aus meiner Disziplin, auf wenige Stufen zu reduzieren. Sie ist nur Sparsamkeit, also letzte professionelle Erkenntnis, also das Gegenteil von wirklicher Primitivität."

« Si ce que je fais laisse parfois une impression de primitivité, cette primitivité s'explique par ma discipline qui réduit tout à quelques rares échelons. Elle n'est qu'économie, donc le dernier jugement professionnel, donc le contraire de la véritable primitivité. »

"내 그림이 가끔 원시적인 인상을 준다면, 그 원시성은 모든 것을 단지 몇 개의 단계로 단순화하는 나의 규율에서 나온 것이라고 설명할 수 있다. 그 규율은 바로 절약이다. 그것은 나의 마지막 전문적 기술이며, 실제로는 진짜 원시성과 반대된다."

「もし私の作品が時として原始的な印象を与えるとしたら、
それは少々簡略化しようとする私の原則から生じたものだと説明できるだろう。
単に節約になるし、最終的な専門家の技術であり、実際には本当の原始性とは対極のものだ」

PAUL KLEE

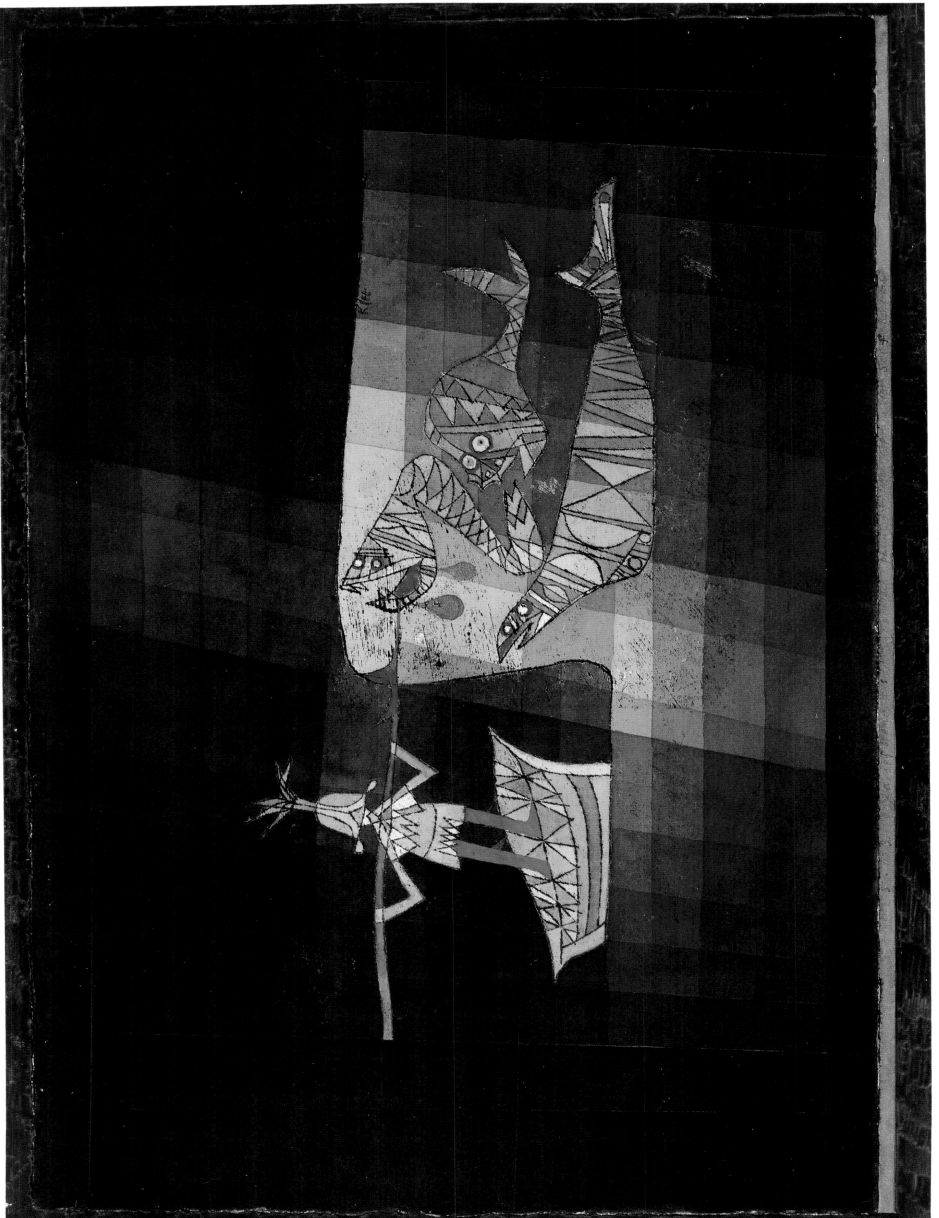

파울 클레, 환상 어린 오페라 '항해사' 중 전쟁 장면, 1923년

Paul Klee
Fight scene from the fantastical comic opera "The Seafarers", 1923, 123
Kampfszene aus der komisch-fantastischen Oper „Der Seefahrer"
Scène de combat de l'opéra comique fantastique « Le navigateur »
환상 희극 오페라 '항해사' 중 전쟁 장면
喜劇的だ幻想的なオペラ「船乗りシンドバッド」から戦いのシーン

Oil tracing, pencil, watercolour and gouache on paper, bottom borders edged with pen-and-watercolour,
pen-and gouache, mounted on cardboard, 34.5 x 50 cm
Basle, Öffentliche Kunstsammlung Basel, Kupferstichkabinett, Gift of Trix Dürst-Haass, Inv. 1986.500

On the left, the seafarer stands in a small boat, his spear raised against three sea monsters.
Like the seafarer himself and his boat, the monsters seem to be constructed from cut-and-folded paper,
decorated with pretty ornaments. Nothing in the picture seems threatening. It is all just theatre.

Links im Bild steht der Seefahrer in einem kleinen Boot und richtet seinen Speer gegen drei
Meeresungeheuer. Sie wirken, ebenso wie der Seefahrer und sein Boot, wie aus Papier ausgeschnitten,
zusammengefaltet und mit schönen Ornamenten bemalt. Nichts in dem Bild ist bedrohlich.
Es ist alles nur Theater.

A gauche, le navigateur est debout dans un petit bateau et pointe sa lance vers trois monstres marins.
On dirait que ceux-ci ont été découpés dans un papier, pliés et pourvus de belles décorations peintes,
tout comme le marin et son bateau. Dans ce tableau, rien n'est menaçant, c'est seulement du théâtre.

왼쪽의 항해사는 작은 배 위에 서서 세 마리의 바다괴물을 향해 창을 겨누고 있다.
항해사와 배, 괴물 모두 예쁘게 장식한 종이를 접고 오려서 만든 것 같다.
이 그림에서는 아무것도 위협적으로 보이지 않는다. 결국 연극일 뿐이다.

画面左側の、小さな舟上に船乗りは立って、3匹の海の怪物に向かって銛を振り上げている。
彼の舟と同じように、船乗り自身ときれいな飾りで装飾された怪物も切り絵で作られたように見える。
まるで、作品の中には怖いものがなにもないようだ。すべては単なる作り事に過ぎないのだ。

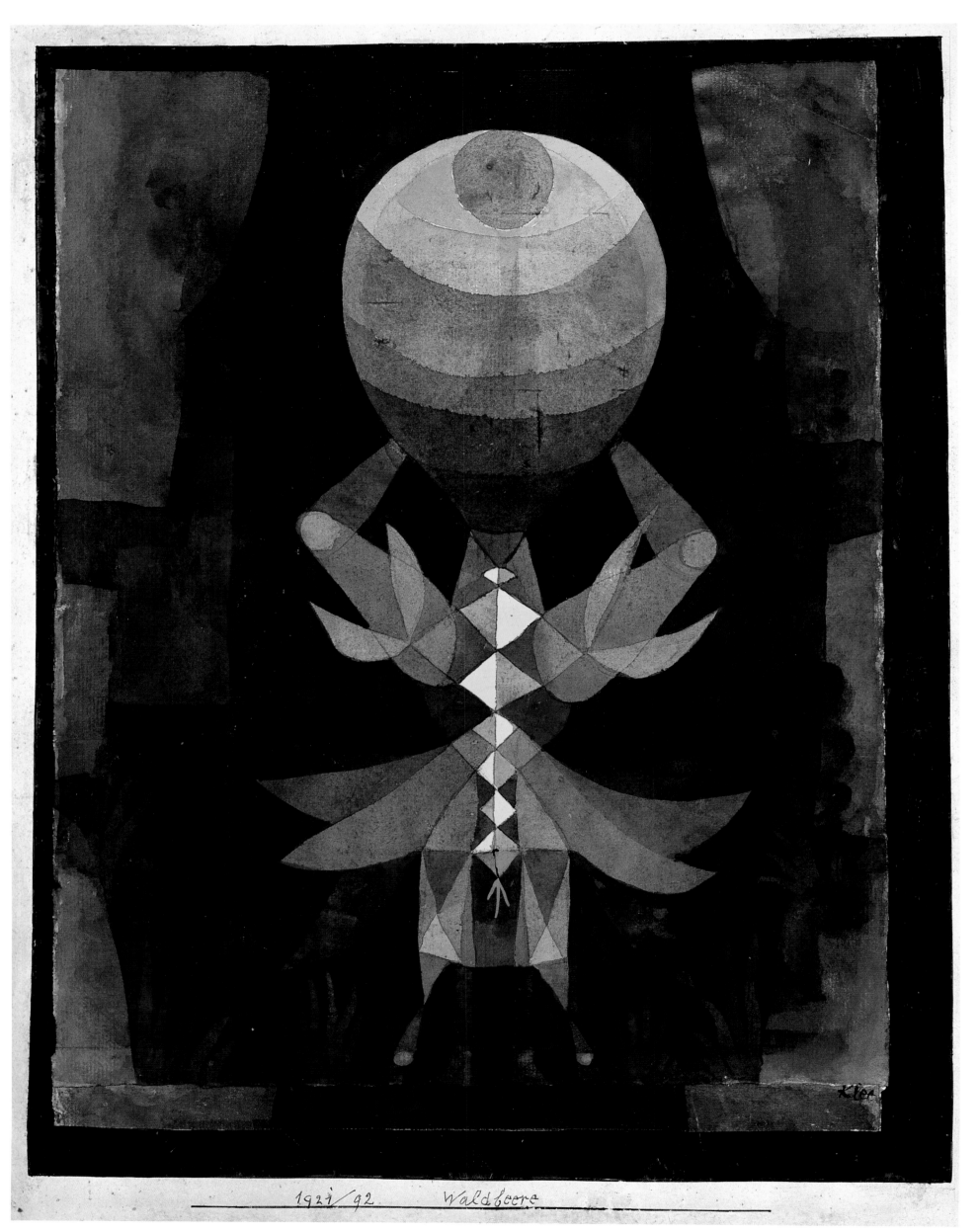

1921/92 Waldbeere

파울 클레 숲의 야생열매, 1921년

Paul Klee
Woodland Berry, 1921, 92
Waldbeere
Baie des bois
숲의 야생열매
ワイルド・ベリー

Watercolour and pencil on paper, cut up and re-combined, edged with pen-and-gouache, 32 x 25.1 cm
Munich, Städtische Galerie im Lenbachhaus, Inv. G 15 694

In his early years at the Bauhaus, Paul Klee worked on his bizarre "theatre of the world".
Puppets, automata disguised as people and animals, mechanically functioning beings perform
in an artificial world.

In den ersten Jahren, die er am Bauhaus verbrachte, arbeitete Klee an seinem skurrilen Welttheater.
Puppen, als Menschen und Tiere verkleidete Automaten, mechanisch funktionierende Wesen agieren
in einer künstlichen Welt.

Au cours des premières années qu'il passa au Bauhaus, Klee travailla surtout dans ses dessins
à son grand théâtre universel grotesque. Les marionnettes, des automates déguisés en hommes
et en animaux, des êtres fonctionnant mécaniquement, jouent dans un monde artificiel.

바우하우스 시절 초기, 클레는 특히 거대하고 기괴한 '세계의 극장'을 그리는 데 열중했다.
인형, 인간과 동물로 가장한 자동장치, 기계적으로 작동하는 존재들이
인공적인 세계 속에서 움직인다.

若い頃バウハウスで、パウル・クレーは奇妙な「世界の劇場」を制作した。人や動物を装った操り人形、
自動機械が機械的に機能する生き物のように演じる作り物の世界である。

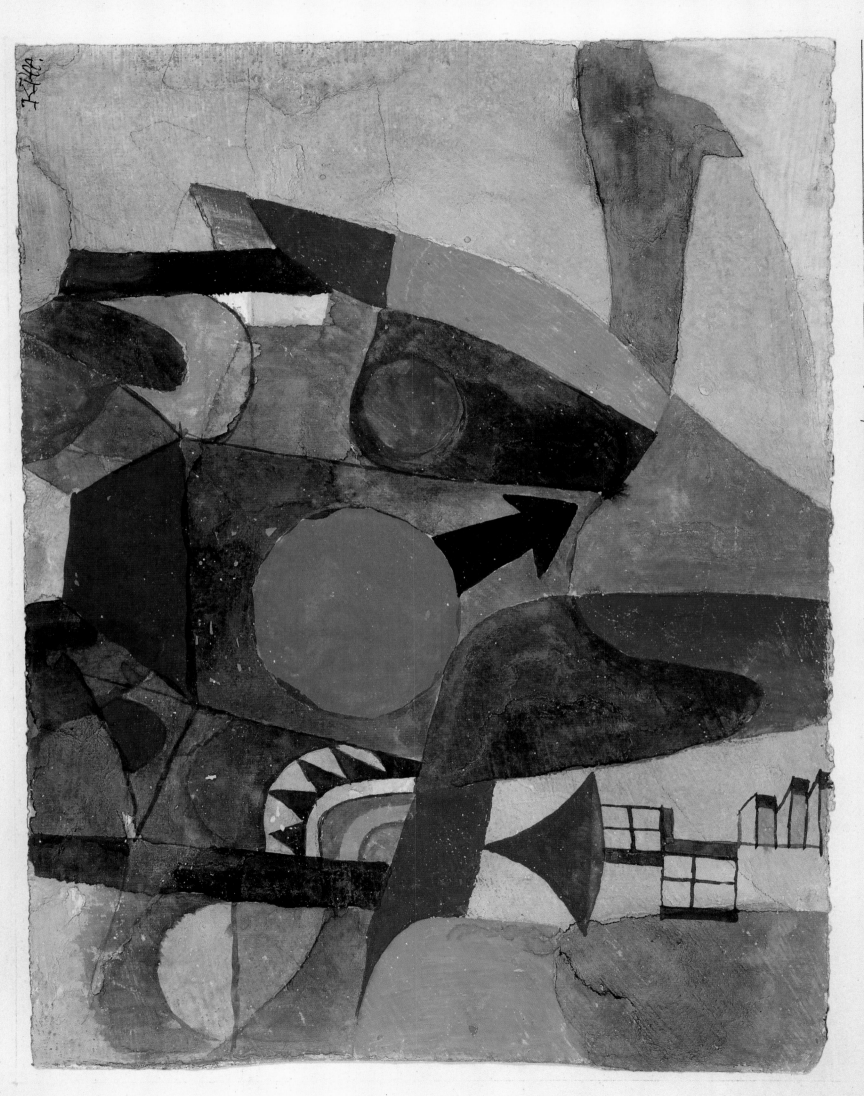

1919 . 247 mit der sinkenden Sonne

파울 클레 지는 해, 1919년

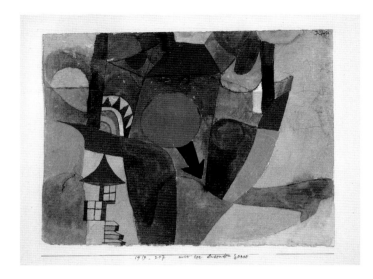

Paul Klee
Sinking Sun, 1919, 247
mit der sinkenden Sonne
Soleil couchant
지는 해
沈む太陽の風景

Watercolour on chalk undercoat, on paper on cardboard, 19.6/20 x 26.2 cm
Switzerland, private collection, Inv. 898

"At one time, people used to paint things that could be seen on Earth, things they liked looking at and
would have liked to see. Now we make the reality of visible things apparent."

„Früher schilderte man Dinge, die auf der Erde zu sehen waren, die man gern sah oder gern gesehen
hätte. Jetzt wird die Realität der sichtbaren Dinge offenbar gemacht."

« On décrivait autrefois des choses que l'on pouvait voir, que l'on aimait ou aurait aimé voir. La réalité
des choses visibles est maintenant rendue évidente. »

"한때 사람들은 볼 수 있는 것, 좋아하는 것, 혹은 보고 싶은 것을 그렸다.
이제 우리는 보이는 사물의 실체를 분명하게 표현한다."

「かつて人々は地上で目にできるものを、見たいものを見たいように描いていた。
今や、私達は目に見えるものの現実を明らかにしている」

PAUL KLEE

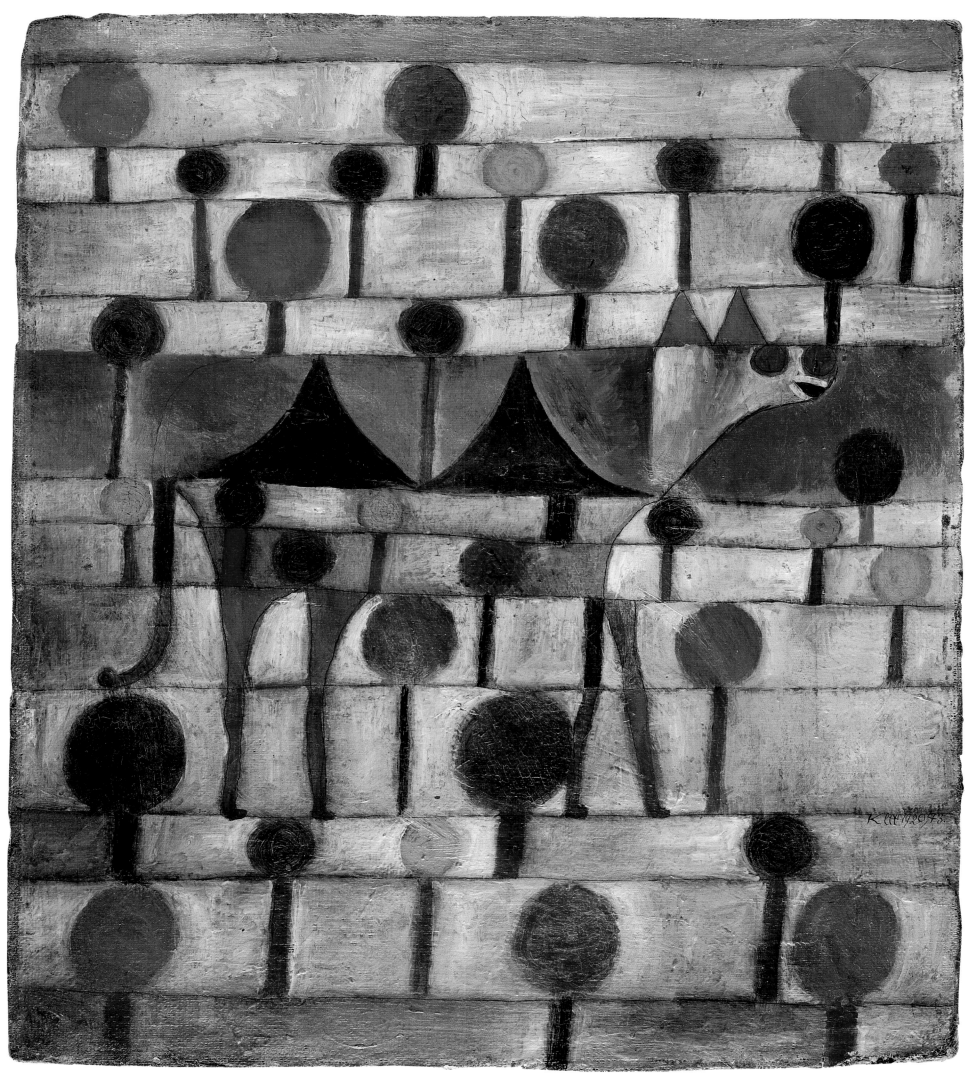

파울 클레 **나무가 있는 율동적인 풍경 속의 낙타**, 1920년

Paul Klee
Camel (in Rhythmic Landscape with Trees), 1920, 43
Kamel (in rhythmischer Baumlandschaft)
Chameau dans un paysage cadencé
나무가 있는 율동적인 풍경 속의 낙타
ラクダ（リズムのある林の風景の中の）

Oil and Indian ink on chalk undercoat on gaze on cardboard, 48 x 42 cm
Düsseldorf, Kunstsammlung Nordrhein-Westfalen, Inv. 1030

"Pictorially pure relations: light to dark, colour to light and dark, colour to colour, long to short,
broad to narrow, sharp to blunt, left right – up down – behind before, circle to square to triangle."

„Bildnerisch reine Beziehungen: Hell zu Dunkel, Farbe zu Hell und Dunkel, Farbe zu Farbe,
lang zu kurz, breit zu schmal, scharf zu stumpf, links rechts – oben unten – hinten vorn,
Kreis zu Quadrat zu Dreieck."

« Des relations pures sur le plan pictural : entre le clair et l'obscur, entre la couleur et le clair-obscur,
entre les couleurs, entre le long et le court, le large et l'étroit, le net et le flou, la gauche et la droite,
le bas et le haut, le premier plan et l'arrière-plan, entre le cercle et le carré ou le triangle. »

"회화적으로 순수한 관계: 밝음과 어두움, 색과 명암, 색과 색,
긴 것과 짧은 것, 넓은 것과 좁은 것, 뚜렷한 것과 흐린 것, 왼쪽과 오른쪽,
낮은 곳과 높은 곳, 전경과 원경, 원과 사각형 혹은 삼각형 사이."

「絵画的に純粋な関係とは、つまり明と暗、色と明暗、色と色、長と短、幅の大小、鈍角と鋭角、左と右、
上と下、前後、丸と四角と三角の関係である」

PAUL KLEE

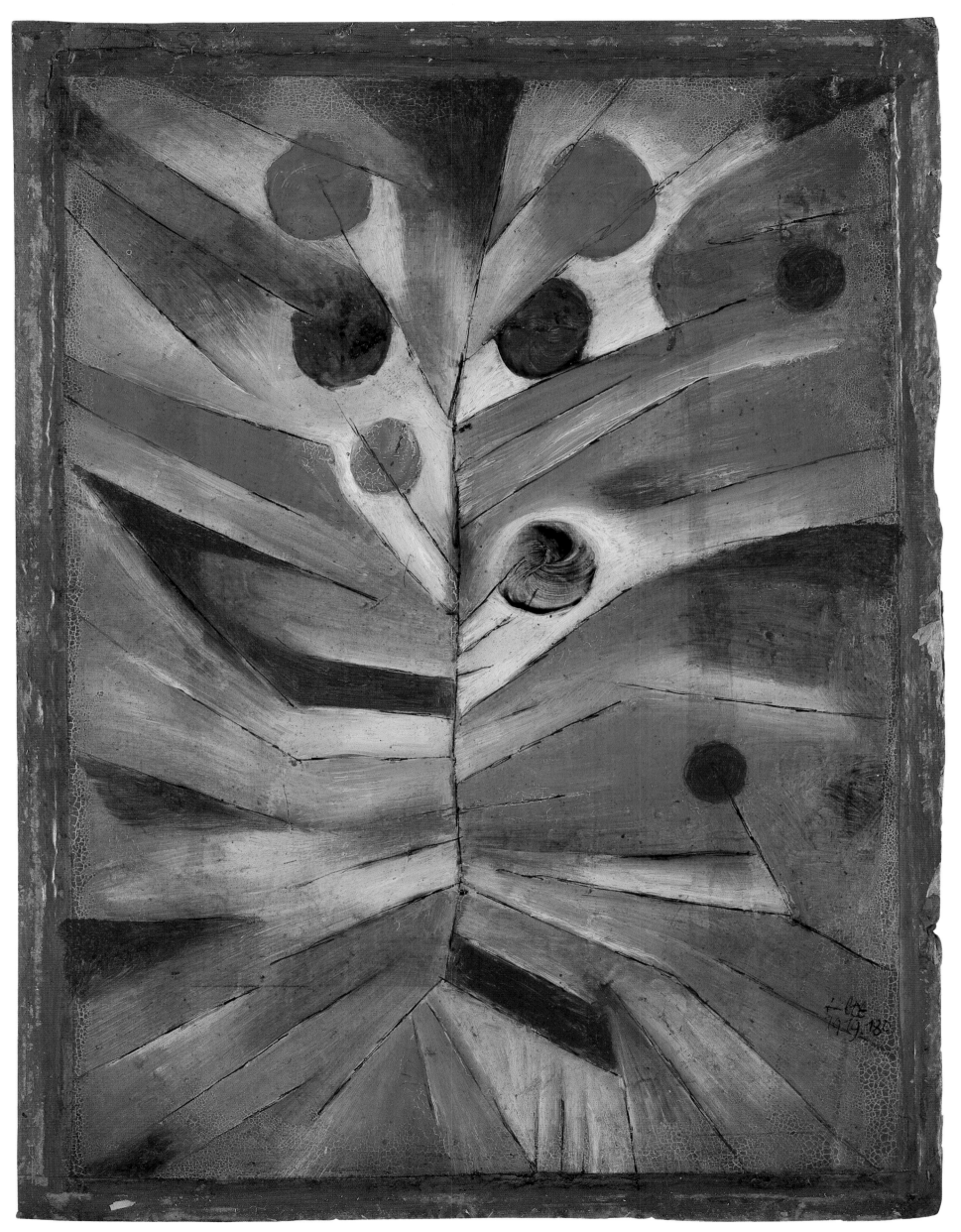

파울 클레 **깃털 달린 식물**, 1919년

Paul Klee
Feather Plant, 1919, 180
Federpflanze
Plante à plume
깃털 달린 식물
羽状植物

Pen-and-oil on linen edged with paper strips,on cardboard, 41.5 x 31.5 cm
Düsseldorf, Kunstsammlung Nordrhein-Westfalen, Inv. 5

"Colour is firstly a quality. Secondly, it is weight, for it not only has a value in terms of colour, but also in terms of light and dark. Thirdly, colour is also dimension, for, in addition to the values mentioned above, it also has its limits, its extension, its measurable size."

„Die Farbe ist erstens Qualität. Zweitens ist sie Gewicht, denn sie hat nicht nur einen Farbwert, sondern auch einen Heiligkeitswert. Drittens ist sie auch noch Maß, denn sie hat außer den vorigen Werten noch ihre Grenzen, ihren Umfang, ihre Ausdehnung, ihr Messbares."

« La couleur c'est d'abord la qualité. Ensuite elle est densité, car elle n'a pas seulement une intensité mais aussi un degré de clarté. Troisièmement elle est encore mesure, car elle a en dehors des valeurs précédentes ses limites, son amplitude, son extension. »

"색은 우선 성질이다. 다음으로 색은 농도다. 색에는 강도가 있을 뿐 아니라 밝기의 차이도 있기 때문이다. 셋째로 색은 크기이기도 하다. 방금 언급한 가치들 외에 색에는 한계와 넓이, 측정 가능한 범위도 있기 때문이다."

「第一に色とは質感である。第二に重さだ。色彩に価値があるばかりか、光と暗さにも価値があるからだ。第三に色は次元でもある。先に述べたことの他に、限界や拡大し、計測可能な大きさがあるからだ」

PAUL KLEE

© 2006 TASCHEN GmbH
Hohenzollernring 53, D–50672 Köln
www.taschen.com
Photo: Walter Klein, Düsseldorf
© VG Bild-Kunst, Bonn 2003

Korean Translation © 2006 Maroniebooks, Seoul
www.maroniebooks.com

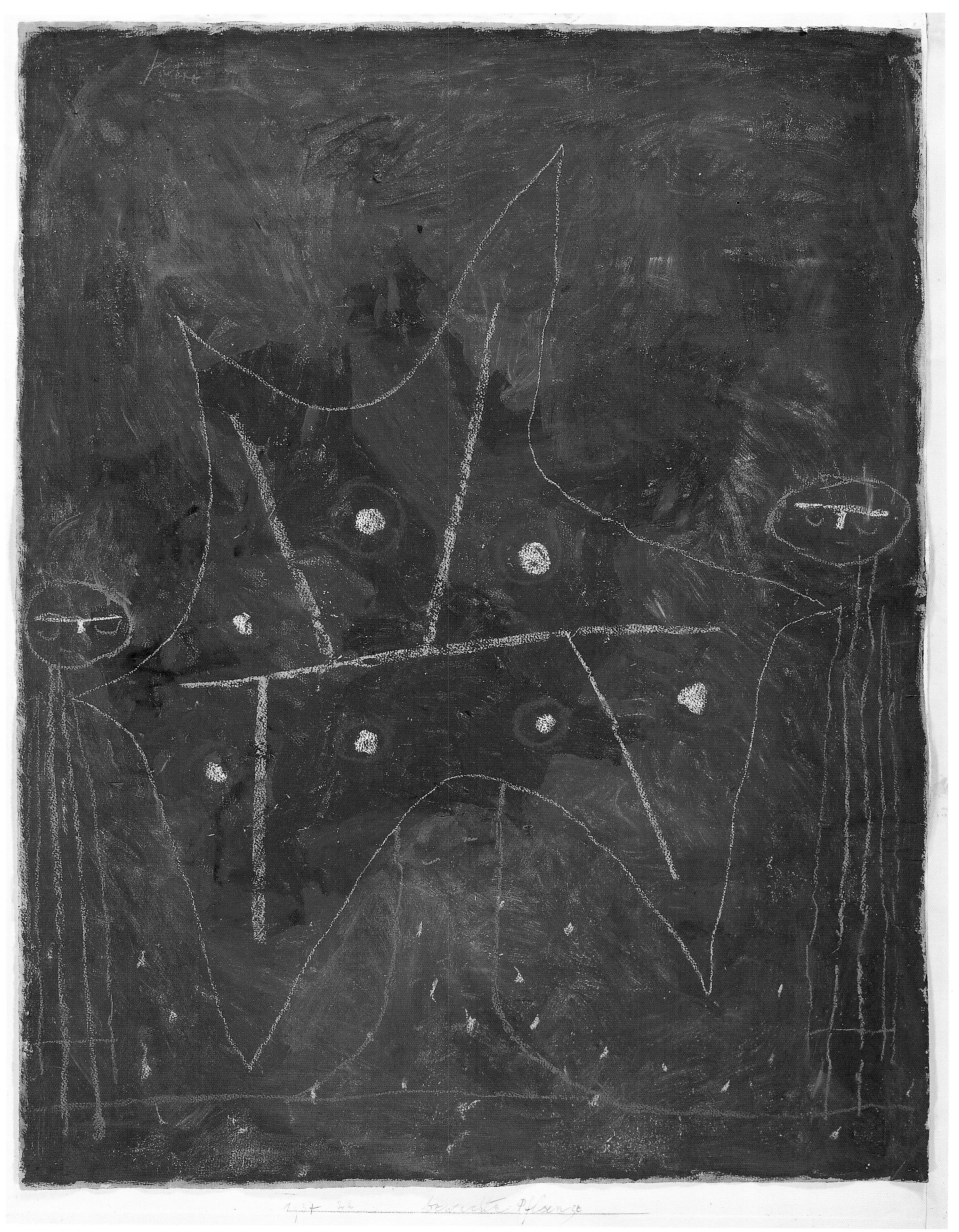

파울 클레 **보호받는 식물**, 1937년

Paul Klee
Guarded Plant, 1937, 22 (22)
bewachte Pflanze
Plante gardée
보호받는 식물
監視された植物

Paste colour and pastel on paper, mounted on cardboard, 62.5 x 48 cm
Mannheim, Städtische Kunsthalle Mannheim, on loan from the State of Baden-Württemberg, Inv. L 1

"The more terrible this world (like today's, for example), the more abstract our art,
whereas a happy world produces art from the here and now."

„Je schreckensreicher diese Welt (wie gerade heute), desto abstrakter die Kunst,
während eine glückliche Welt eine diesseitige Kunst hervorbringt."

« Plus ce monde (celui d'aujourd'hui justement) devient épouvantable,
plus l'art devient abstrait, alors qu'un monde heureux produit un art orienté sur l'ici-bas. »

"이 세상이(바로 오늘날처럼) 점점 끔찍해질수록, 예술은 점점 추상적이 된다.
반면 행복한 세상은 지금, 여기를 지향하는 예술을 만들어낸다."

「この世界が恐怖に満ちていればいるほど（たとえば今日のように）、芸術は抽象的となり、
幸福な世界は世俗的な芸術を創造する」

Paul Klee

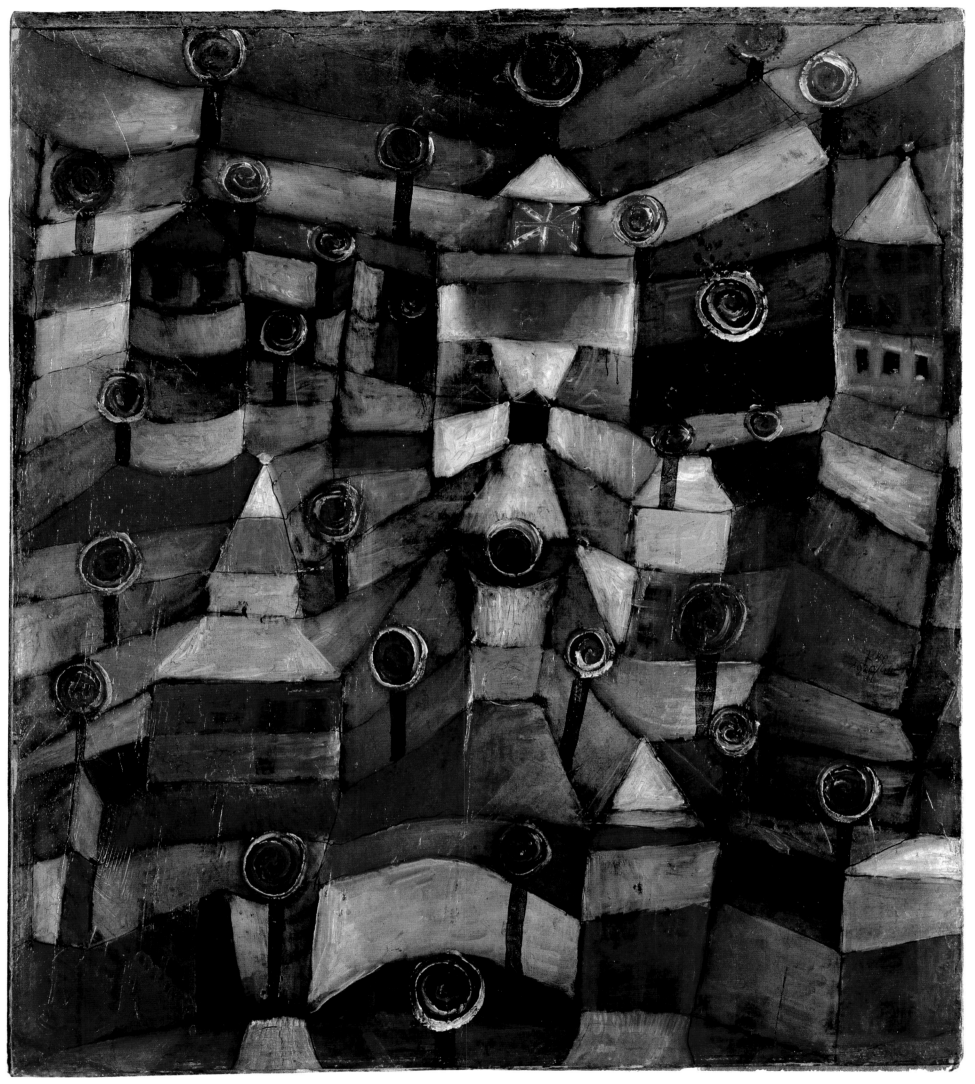

파울 클레 **장미 정원**, 1920년

Paul Klee
Rose Garden, 1920, 44
Rosengarten
Roseraie
장미 정원
バラ園

Oil and ink on paper on cardboard, 49 x 42.5 cm
Munich, Städtische Galerie im Lenbachhaus, The Gabriele Münter and Johannes Eichner Fund
and Städtische Galerie, Inv. G 16 102

"Art does not reproduce what is visible, but makes things visible. The purer the graphic work,
i. e. the greater the importance attached to the formal elements used in the graphic representation, the
more inadequate is the preparation for the realistic representation of visible things"»

„Kunst gibt nicht das Sichtbare wieder, sondern macht sichtbar. Je reiner die graphische Arbeit,
das heißt, je mehr Gewicht auf die der graphischen Darstellung zugrunde liegenden Formelemente
gelegt ist, desto mangelhafter die Rüstung zur realistischen Darstellung sichtbarer Dinge."

« L'art ne reproduit pas le visible, il rend visible. Plus le dessin est pur, c'est-à-dire plus on accorde
d'importance à la forme qui sous-tend la représentation graphique, plus la structure qui sert à la
représentation réaliste des objets visibles est faible .»

"예술은 보이는 것을 재현하는 것이 아니라 사물을 보이도록 만드는 것이다.
드로잉이 순수할수록, 즉 재현의 기초를 이루는 형태에 중요성을 둘수록,
보이는 것을 사실적으로 재현하기 위한 준비는 필요 없어진다."

「芸術は目に見えるものを再現するのではなく、ものを見えるようにすることである。
より純粋なグラフィック作品はすなわち、その表現に使われる形式的要素に付随する重要性もより大きく、
より未熟な作品は目に見えるものの写実的表現への下準備でしかない」

PAUL KLEE

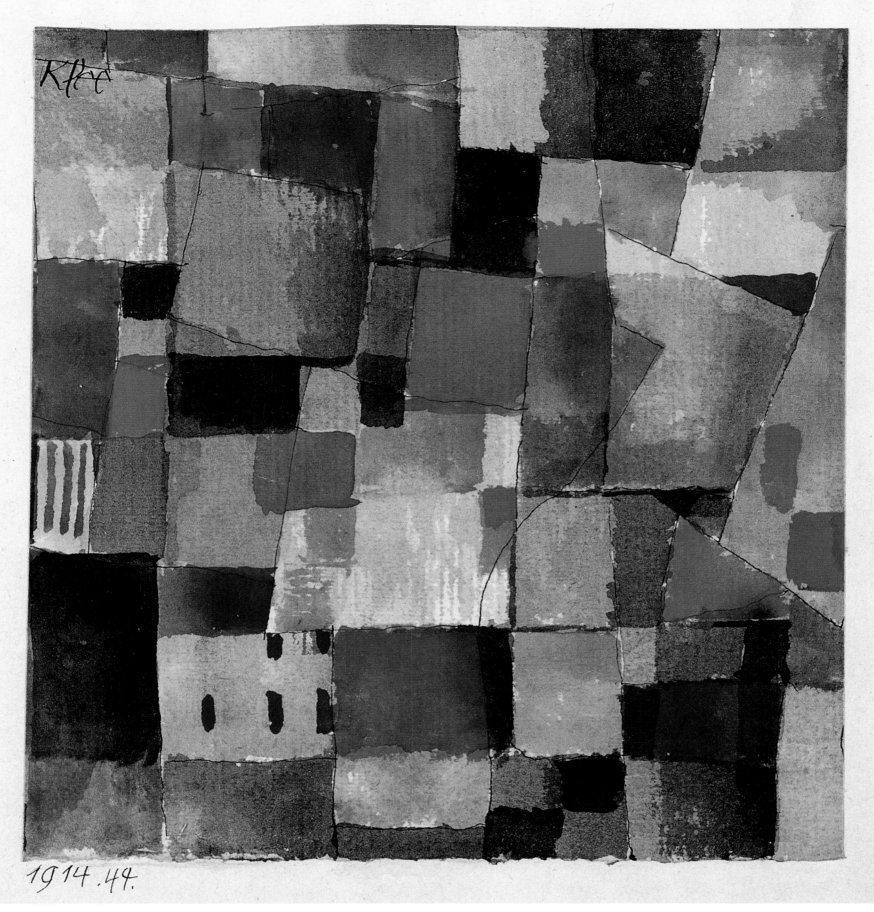

파울 클레 **무제**, 1914년

Paul Klee
Untitled, 1914, 44
Ohne Titel
Sans titre
무제
無題

Watercolour and ink on paper on cardboard, 13.5 x 12.5 cm
Hannover, Sprengel Museum, Collection Sprengel, Inv. I/105

In the water colours he painted in Tunisia, Klee worked with transparent paints applied one on top of the other. Pictures of buildings and landscapes were created by adding only a few details to a net of geometric shapes.

In seinen Tunis-Aquarellen hat Klee mit durchsichtigen Farben gearbeitet, die er übereinanderlegte. Aus einem Netz geometrischer Formen entstanden durch wenige Zusätze Architektur- und Landschaftsbilder.

Dans ses aquarelles tunisiennes, Klee a travaillé avec des couleurs transparentes qu'il superposait. Un réseau de formes géométriques auquel s'ajoutaient quelques lignes générait sur les tableaux une architecture ou un paysage.

튀니지에서 그린 수채화에서 클레는 투명한 색을 겹쳐 칠했다.
건물과 풍경은 기하학적 형태의 그물에 약간의 세부묘사를 더해서 그렸다.

チュニスで描いた水彩画では、クレーは透明な色を重ね合わせて使っている。
建物や景色の絵では、幾何学的な形の中にわずかに細部が描き込まれているにすぎない。

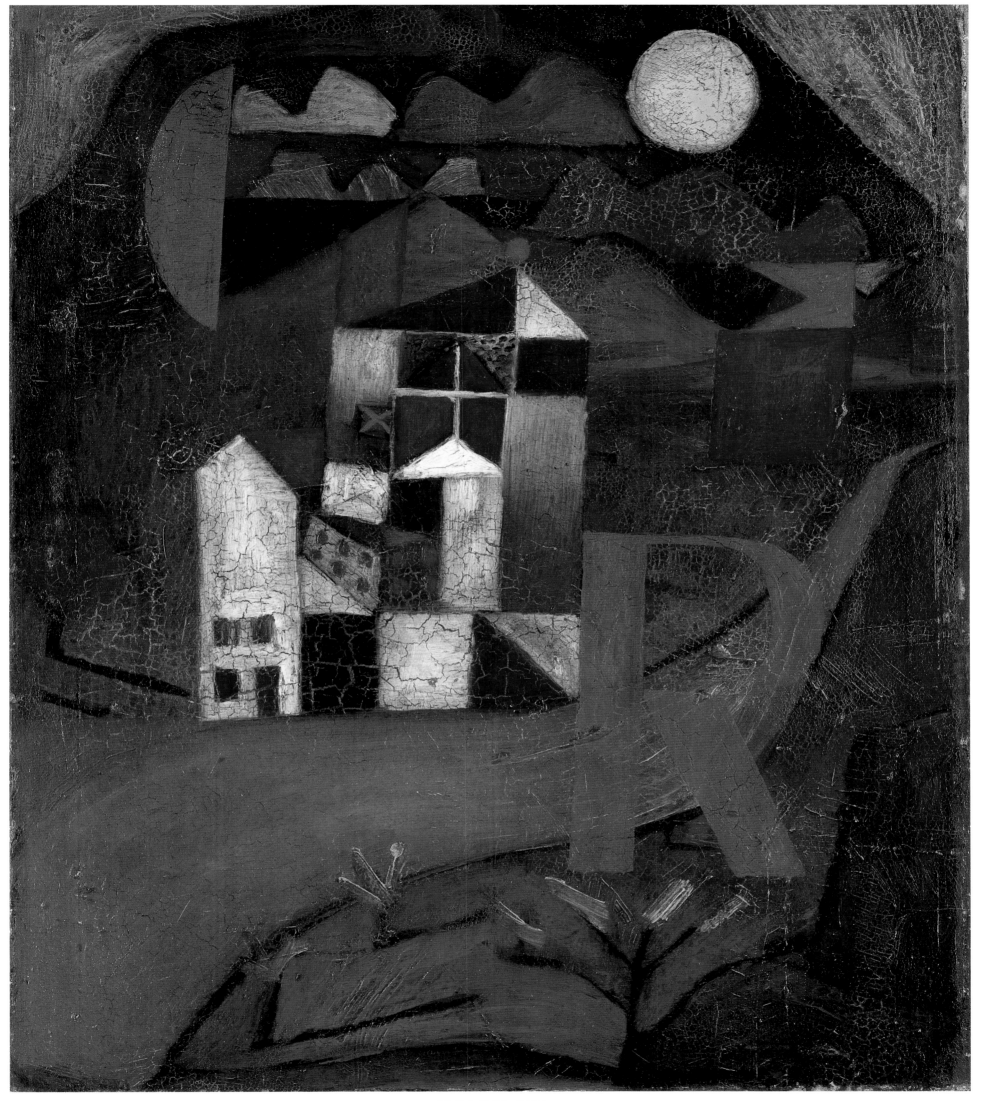

파울 클레 **빌라 R**, 1919년

Paul Klee
Villa R, 1919, 153
빌라 R
R荘

Oil on cardboard, 26.5 x 22 cm
Basle, Öffentliche Kunstsammlung Basel, Kunstmuseum, Inv. 1744

"Of more importance than Nature and the study of Nature is one's attitude to the contents of one's paintbox. One day I must be able to indulge in free fantasias on the colourful keyboard of a row of watercolour paints."

„Wichtiger als die Natur und ihr Studium ist die Einstellung auf den Inhalt des Malkastens. Ich muss dereinst auf dem Farbklavier der nebeneinanderstehenden Aquarellnäpfe frei phantasieren können."

« Plus important que ne le sont la nature et les études d'après nature est l'attitude de l'artiste envers le contenu de sa boîte à couleurs. Je dois pouvoir un jour improviser librement sur le clavier chromatique que forment les godets d'aquarelle. »

"자연과 자연을 연구하는 일보다 더 중요한 것은 물감 상자의 내용물을 다루는 화가의 태도이다.
언젠가는 다양한 음을 지닌 건반과도 같은 수채물감 접시를 능숙하게 다룰 수 있어야 하리라."

「自然と観察以上に重要なのは、絵の具箱の中身に対する人の態度だ。
いつの日か、私は水彩絵の具がずらりと一列に並んだカラフルなキーボードを使って
自由な空想に耽ることができるにちがいない」

PAUL KLEE

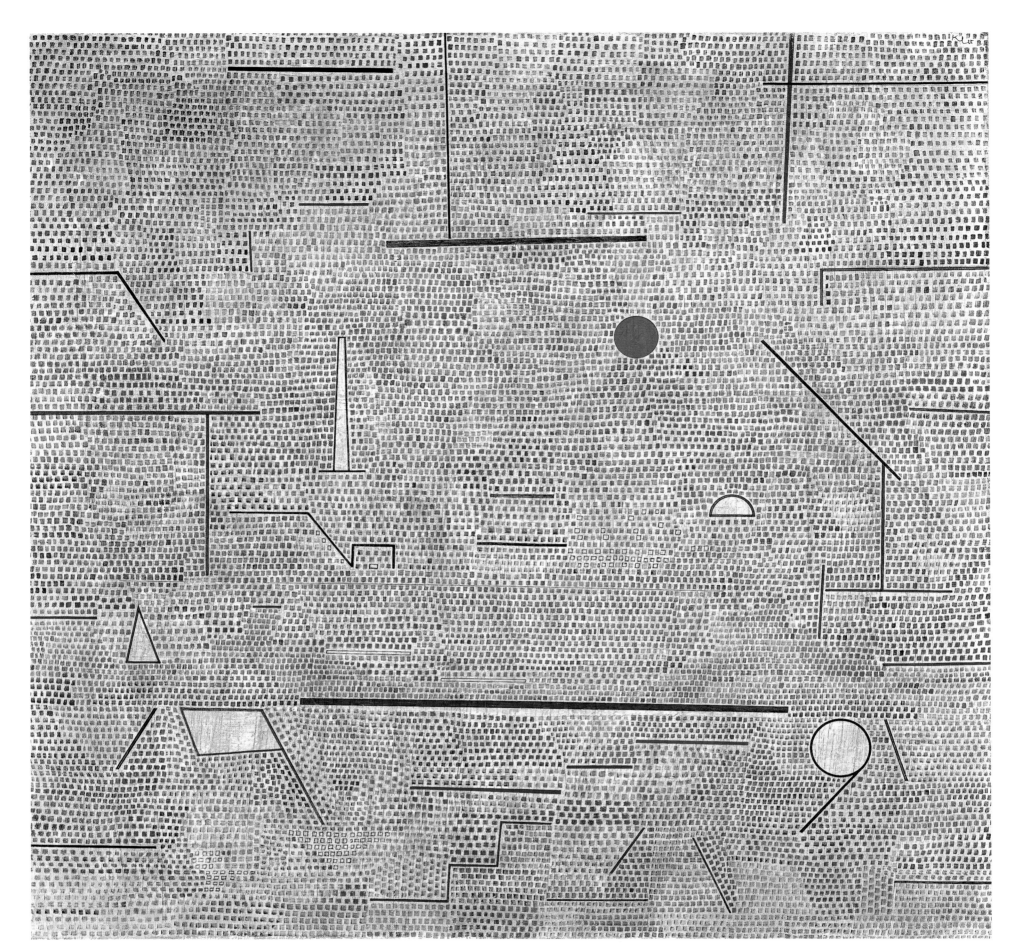

파울 클레 **빛, 그리고 다른 것들**, 1931년

Paul Klee
Light and Something More, 1931, 228 (V8)
Das Licht und Etliches
La lumière et d'autres choses
빛, 그리고 다른 것들
光と何かそれ以上のもの

Watercolour, pen-and-ink, and pencil, on undercoat of oil-based gloss paint, on canvas mounted on stretcher, 95.9 x 98 cm
Munich, Bayerische Staatsgemäldesammlungen, Pinakothek der Moderne, Inv. 14 070

"The nature of graphic art easily makes abstraction tempting, and rightly so.
The imaginary character is both blurred and has a fairy-tale quality about it,
while at the same time expressing itself very precisely."

„Das Wesen der Graphik verführt leicht und mit Recht zur Abstraktion.
Schemen- und Märchenhaftigkeit des imaginären Charakters ist gegeben und
äußert sich zugleich mit großer Präzision."

« L'essence même du dessin tend, à raison, à nous mener vers l'abstraction.
L'aspect schématique et fantastique du caractère imaginaire est donné et
s'exprime en même temps avec une grande exactitude. »

"그래픽 아트는 본래 우리를 추상으로 기울게 만드는 성질이 있으며, 마땅히 그래야 한다.
상상 속의 캐릭터는 간략하고 환상적이면서도 아주 정확하게 표현된다."

「グラフィック・アートが持つ性質は抽象を魅力的に変える。まさに的確に変える。
空想の登場人物はぼやけていて、おとぎ話のような特徴を持っている一方、
同時に自らを極めて正確に表現する」

PAUL KLEE